GLACIER · IMAGES FROM THE CROWN OF THE CONTINENT

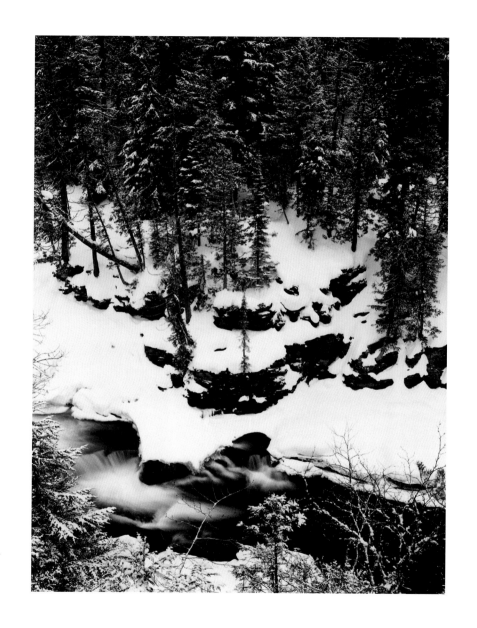

MARSHALL NOICE

GLACIER
IMAGES FROM THE CROWN OF THE CONTINENT

foreword by Marshall Noice

Light on Snow, The Glacier Landscapes of Marshall Noice
BY DAVID LONG

Whitefish Editions

Marshall Noice - Glacier, Images from The Crown of The Continent
Copyright © Marshall Noice 1995. All rights reserved

Light on Snow - The Glacier Landscapes of Marshall Noice
Copyright © David Long 1993. All rights reserved
originally appeared in Whitefish, Vol.VI, No. II

ISBN: 0-9645477-5-9

Published by:
Whitefish Editions
P.O. Box 4763
Whitefish, MT 59937
1-800-893-0963

Printed and bound in Canada

Cover Photograph: *Spring Snow, Lake MacDonald Glacier, 1978*
Frontispiece: *MacDonald Creek Gorge, Snow, 1993*

For information regarding the photographs:
Marshall Noice
647 6th St. East
Kalispell, MT 59901
1-800-775-1743
e-mail: mnoice @ cyberport. net

For my mother, Marion Gerrish

LIGHT ON SNOW

The Glacier Landscapes of Marshall Noice

by David Long

It's a sweet fall afternoon, the light soft and kind, an unexpected reward after our dismal, drizzly summer. Marshall Noice and I are talking in the dormered gallery above his studio in Kalispell. The portfolio is spread along the wall in front of us, shots of Glacier Park in winter culled from the pilgrimages he's made there since his earliest days as a photographer. Most he took from skis or snowshoes, using a Sinar 4x5 view camera. The titles are Zen-like: *Birch, Red Rock Point. New Snow, Logan Pass. Snowy Branches.* The images seem intensely lucid, the detail supernaturally crisp (keener, in fact, than your eye could accomplish); the whites and grays form an apparently infinite spectrum. They have a quality Renaissance painters revered: their technique is invisible, they make the difficult seem effortless.

"They're as much about the space between objects as about the objects themselves," he says. "If it's possible to photograph air, that's what I'm trying to do."

You can be very alone in Glacier, but in high summer, there's a giddy, communal feeling, as well. The Park has a long history of socializing—the old lodges and chalets, built with railroad money, were great gathering spots. Early-day tourists arrived from Chicago on the Oriental Limited; we see them in pictures, the jaunty women picnicking in the bear grass, the men with their vests and straw boaters. The waitresses pose in milk maid outfits. And there's the famous shot of FDR blessing Going to the Sun Road, that great engineering marvel. Today, visitors flock to the Park more aware than ever what a national treasure it is, what an *island.* Any afternoon in summer

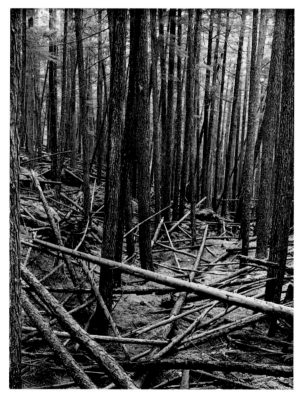

Cathedral, 1981

you can count the plates from forty states in the lot at Logan Pass. People may come to Glacier to get away from each other, but they're perfectly happy to share their mountain-struck euphoria, their life stories, their Hershey bars.

But winter in Glacier is something else altogether. Not just long and serious, not just the off-season. It's about nature being itself, stonily indifferent to humankind. This emptiness—you could call it quietude or serenity—is at the heart of Marshall Noice's winter landscapes.

It's their gift.

We talk about the individual prints, then the larger issues of landscape photography. He describes a day's shooting, the drive in at dawn, the solitude, the difficulties in getting going. You can have too many expectations. I remind him of something Wallace Stegner once said, that the land offered its wisdom to him only after he'd submitted to it completely. "Absolutely," Marshall says. "You have to empty your bag before you start working."

Protected as it is, Glacier is an apolitical environment for him, and it's easier there to keep the pictures free of ideology. Still, art always makes some political statement—it exists to be shown. Landscapes especially, I think, because the way we treat the land is such a loaded issue. Even if an artist's motive, as William Carlos Williams said, is to give witness to splendor.

And another dilemma: what if you make a picture people find overwhelmingly beautiful—then they come to the place and, in their numbers, spoil it?

Raised in Minnesota, Marshall finished his high school in Kalispell. He fought off isolation by immersing himself in books (he's still a voracious reader), in collections of photographs and, later on, by trips to meet and work with a few of his heroes—Al Weber, Barbara Crane, Brett Weston, and Ansel Adams. It interests me how artists process their influences, so I ask the obvious question, how his pictures of Glacier differ from Adams' legendary work in Yosemite. Like many landscape photographers of his generation, he admits readily, he absorbed a great deal of Adams' technique and theory—you couldn't *not*. "But with Ansel's pictures," he says, "the light is very dramatic— it's always a fleeting moment, cloud patterns and so on. In mine, there's not such a discrete slice of time. There's more a feeling of timelessness." Though it might seem an odd comparison at first, he feels a greater kinship to the photographs Frederick Evans made of European cathedrals. One of the Glacier pictures is, in fact, called *Cathedral*, a moody shot of fallen lodgepole pines. They lie spilled like pickup sticks, yet the shot seems classically composed, stark and somehow reverent.

Since 1978, he's operated a commercial photography studio in Kalispell, where he does a prodigious trade in portraits and sundry commission work—he's photographed everything from microchip washers to kiwi fruits to boys with boa constrictors. His photographs (both landscape and portrait) have been shown in dozens of exhibits, including the University of Wisconsin's American Master Series; he's won awards in this country and abroad (in 1992 he was given the Montana Governor's Cultural Trust Award).

Photography would seem to be his life, but actually he's a man riddled with enthusiasms. A quick study, intuitive, decisive—he gives the impression of never being quite at rest. For the past few years, he and painter Terry Nelson have collaborated on a series of huge, exuberant canvases. Noisy with color, sly, hilariously sexual. Then there's the music. A drummer in various road bands

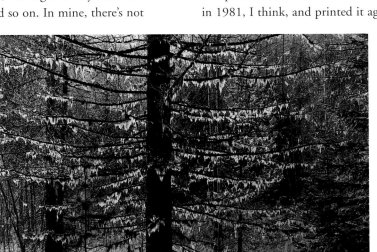

Goat's Beard Lichen, 1981

when he was younger, he has a lifelong passion for Chicago-style blues (since 1989 he and I have played in a local blues band called "Tut & the Uncommons"). I find it a deep delight to think that the same man who made the Glacier pictures can hunker in behind a drum kit and sing *Can I be your little dog while your big dog's gone?*

Another problem that fascinates me is how artists can keep digging away at their obsessions without going stale or copying themselves. "One thing time has shown me," Marshall says, "is that I have to get past my surface attraction to a picture. I have to live with it. *Goat's Beard Lichen*, for instance. I took that in 1981, I think, and printed it again just last year—it continues to intrigue me. So that's part of it." (It's a picture that keeps drawing my attention, too; the asymmetrical spine of a dead tree, the lichen dripping off it, eerily backlit.)

If his eye has sharpened over time, so has his darkroom expertise. "That's half the fun," he says. He believes that the picture is made in the field—that is, he won't surf through his negatives looking for a piece of something to print. He does a minimum of cropping. But he's learned a great deal about the chemistry of black and white printing, what can be done to make specific parts of the print work the way he wants them to work.

And it's in the darkroom that he begins to understand his attraction to a particular shot, what quality lifts it out of the ordinary. "In the past couple of years," he says, "I think I've found a greater ability to create an image that's less like the way the landscape looks, than the way it feels. It's an abstraction, that's what I've come to understand. It's nonliteral." He turns back to *Spring Snow, Lake MacDonald*. "If you were standing there that day it wouldn't have looked like that."

We sit in the presence of the pictures a while longer, not talking. "In the end I think they're hopeful statements," he says finally. Outside, a gust rattles the birch leaves and a few come spinning down.

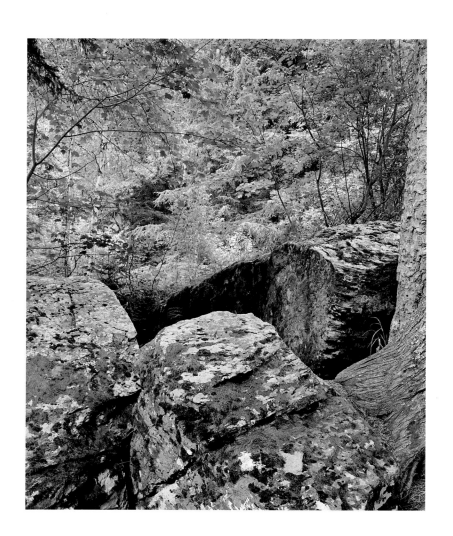

FOREWORD

George Bird Grinnell, an early advocate for the establishment of Glacier National Park, described the country as "The Crown of the Continent." A century later, his words still ring true for me. The Park is a place unlike any other I know. The sheer cliffs of argillite and schist, the gem-like crystalline pools, the ubiquitous thundering cascades, the glaciers. These dynamic elements conspire to make us mindful of the limits of human influence and of the brevity of our time on earth. They inspire exaltation.

My days in Glacier have been ones of altered perspective. Ideas and events of great importance on a human scale can become inconsequential in this enormous space. Large becomes small. Small becomes large. Minutiae take on significance all out of proportion to their size when, in a moment of gracious insight, the circle of life, as our forebears called it, is revealed to us.

I've had the great good fortune to watch the seasons change in Glacier National Park for the past twenty-five years. Like the seasons, I've been changed by the time I've spent in Glacier. Humbled, renewed, my only accomplishments are these images locked in silver. Reflections, if you will, of the jewels I've seen in The Crown of the Continent.

Marshall Noice,
Kalispell, Montana,

Facing Page, SPRING, 1994

JULY SUNRISE, ST. MARY LAKE, 1994

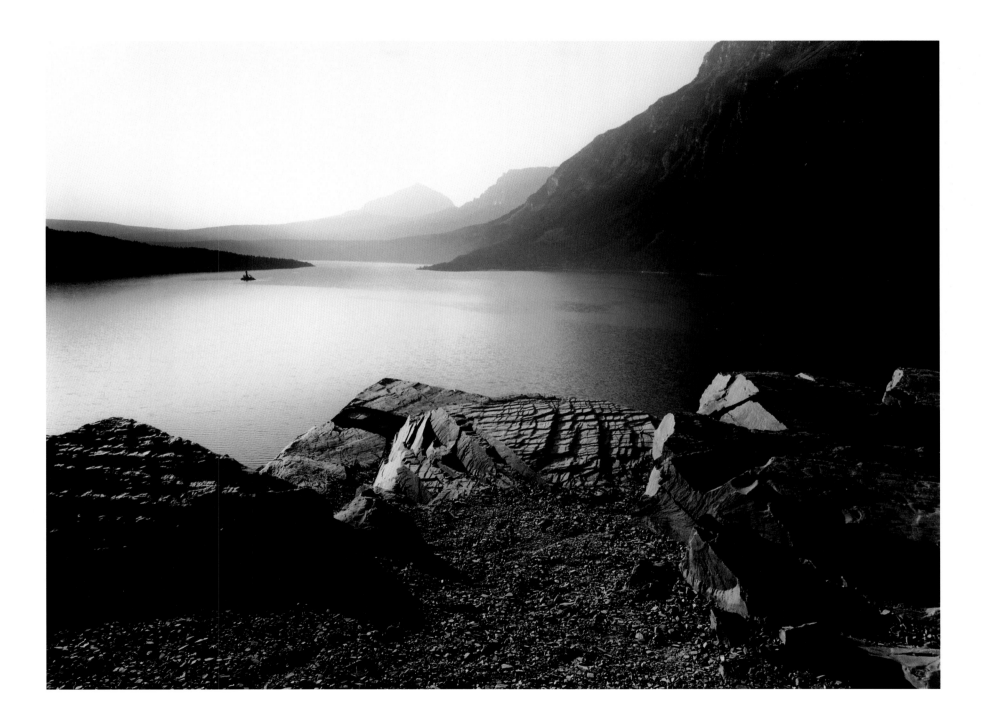

JANUARY SNOW, LAKE MacDONALD, 1992

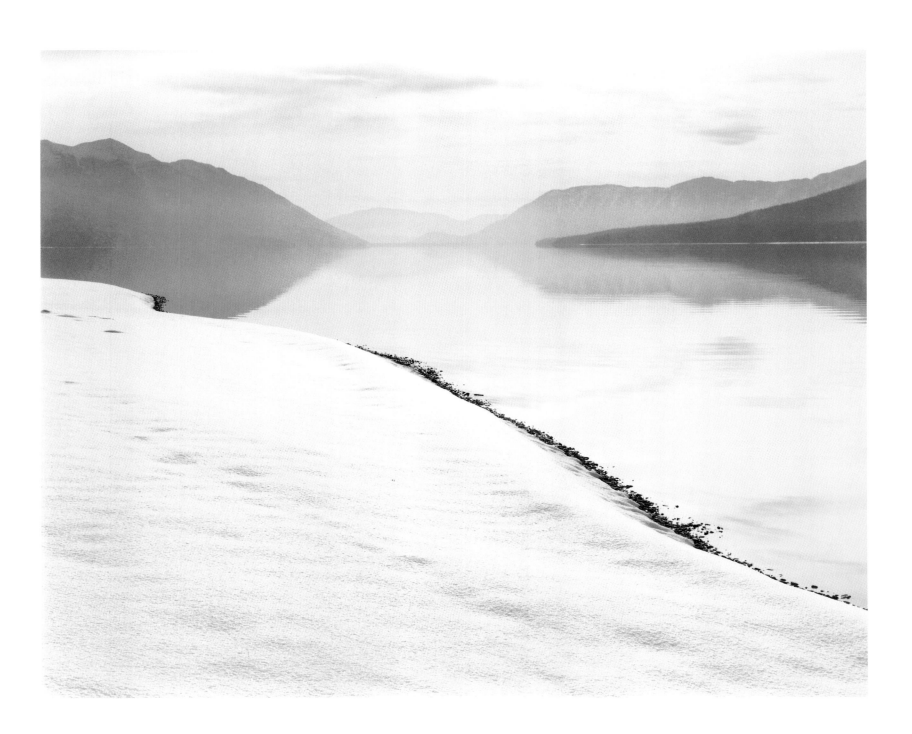

SNOWY BRANCHES, 1982

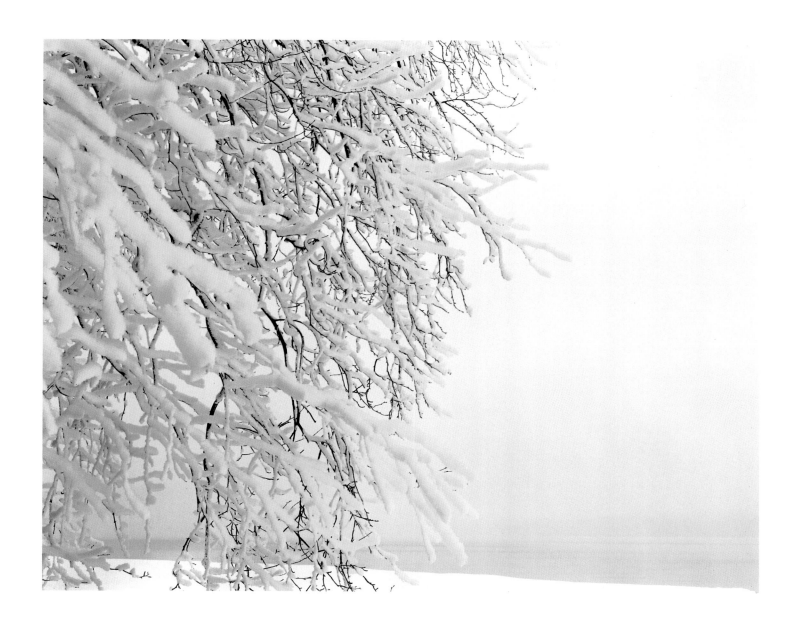

MacDONALD CREEK GORGE, 1993

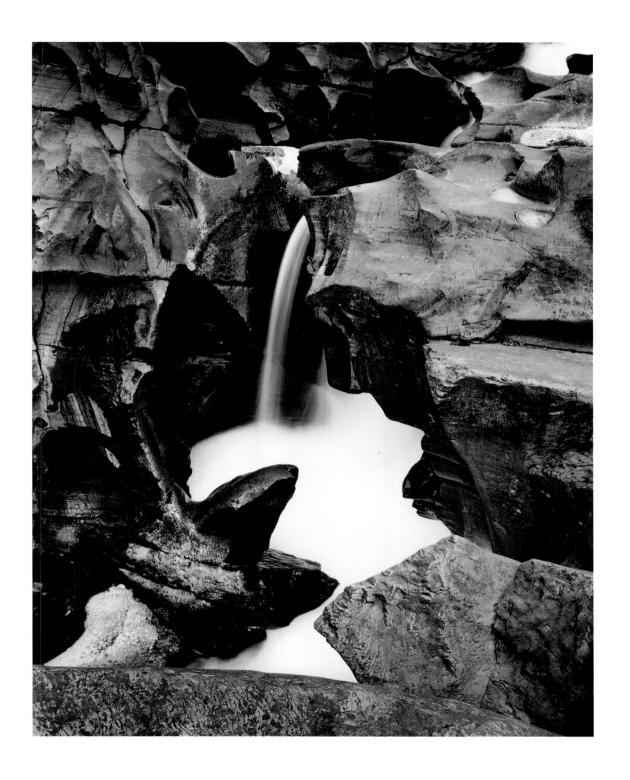

WINTER BRUSH, 1994

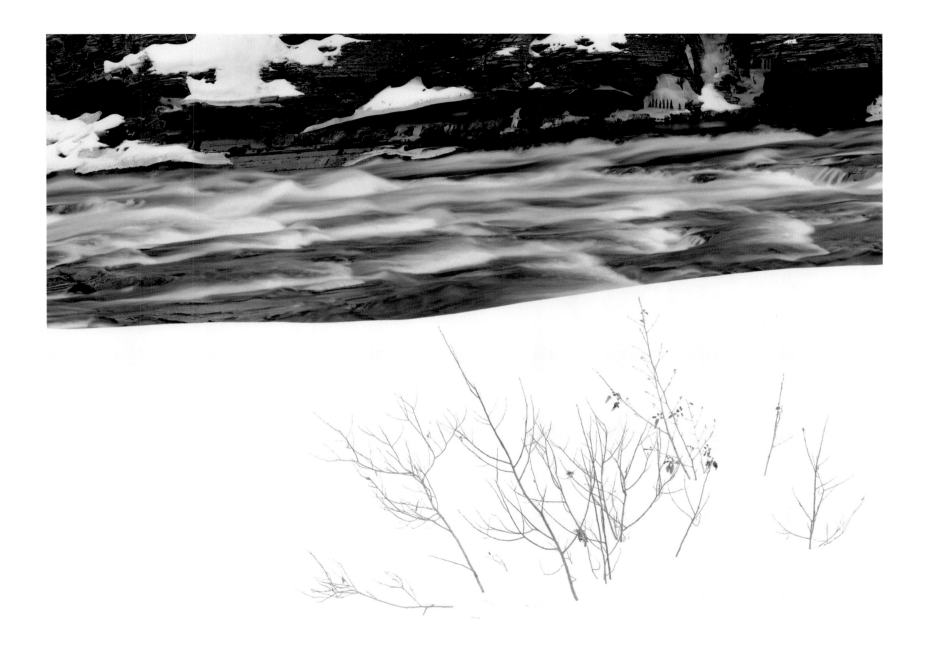

OVERLOOK, ST. MARY LAKE, 1981

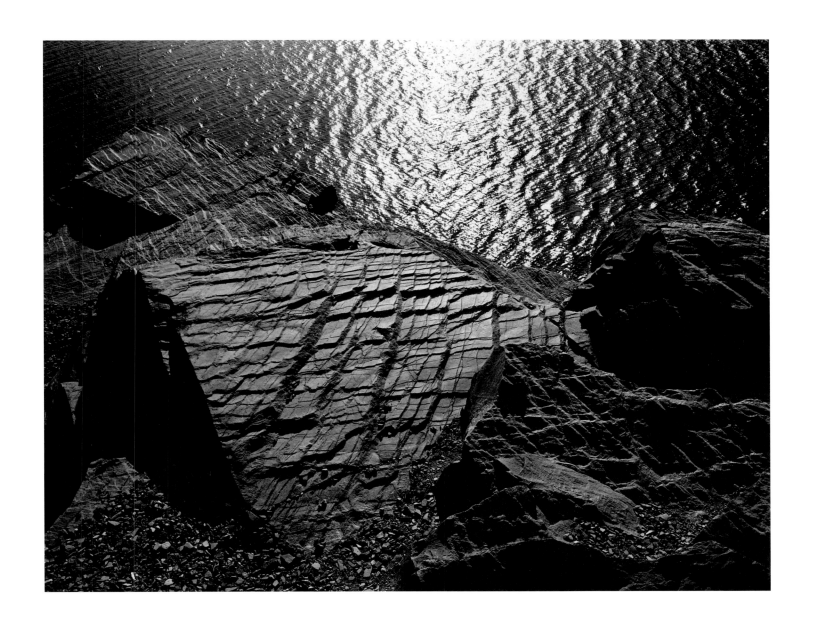

SPRING SNOW, LAKE MacDONALD, 1978

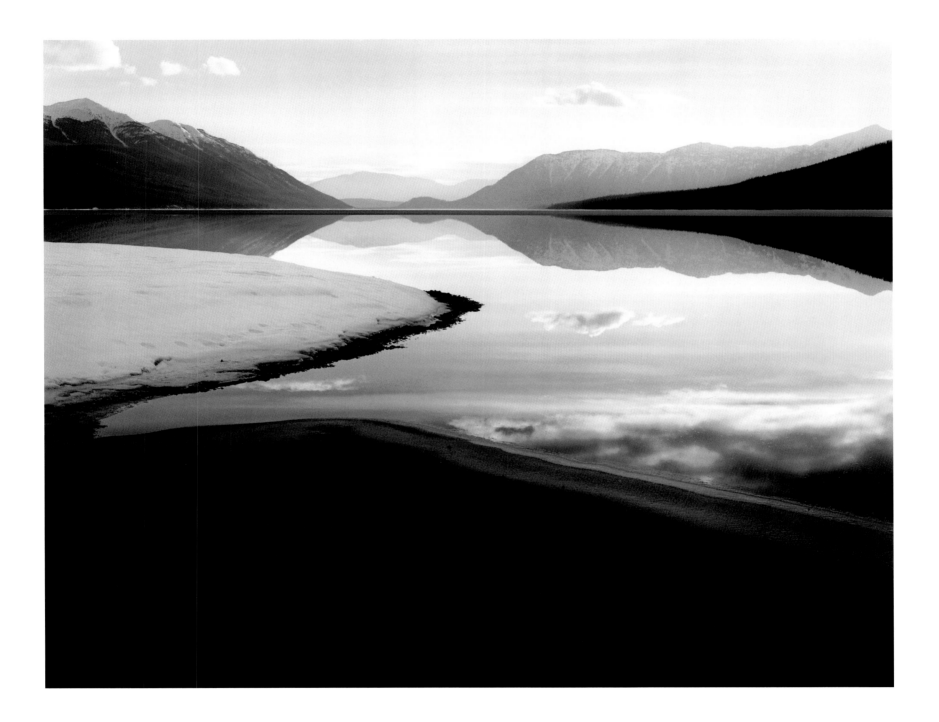

BIRCHES, GLACIER WALL, 1992

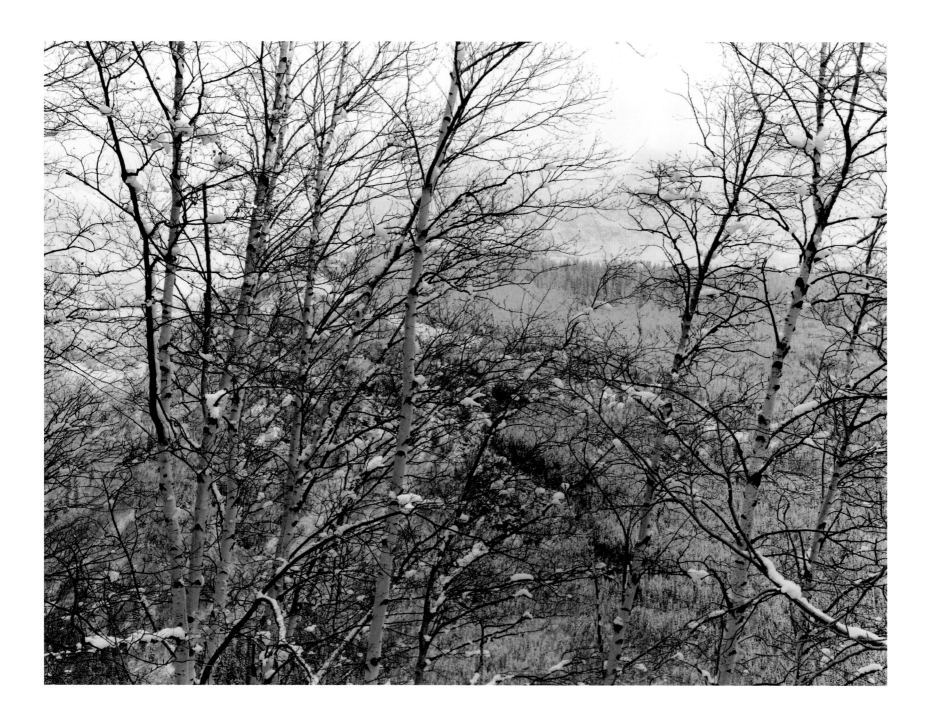

ANCIENT BOULDER, 1982

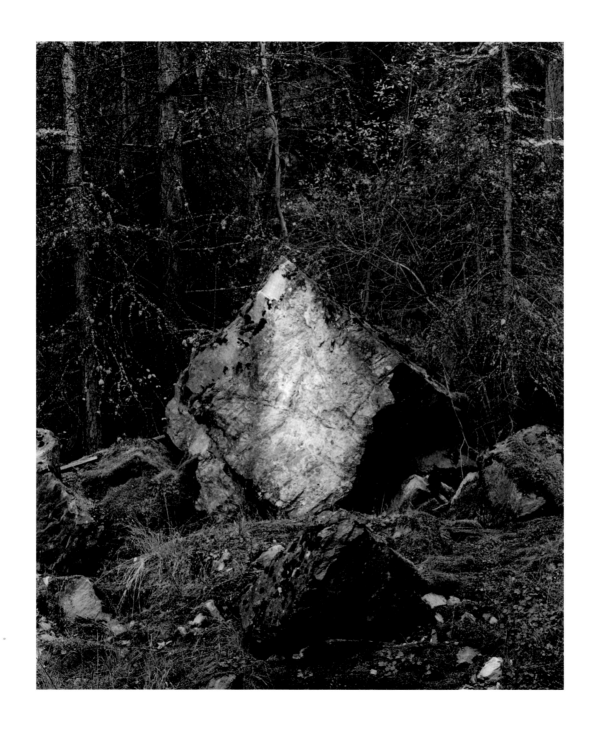

SILVER STAIRS, 1984

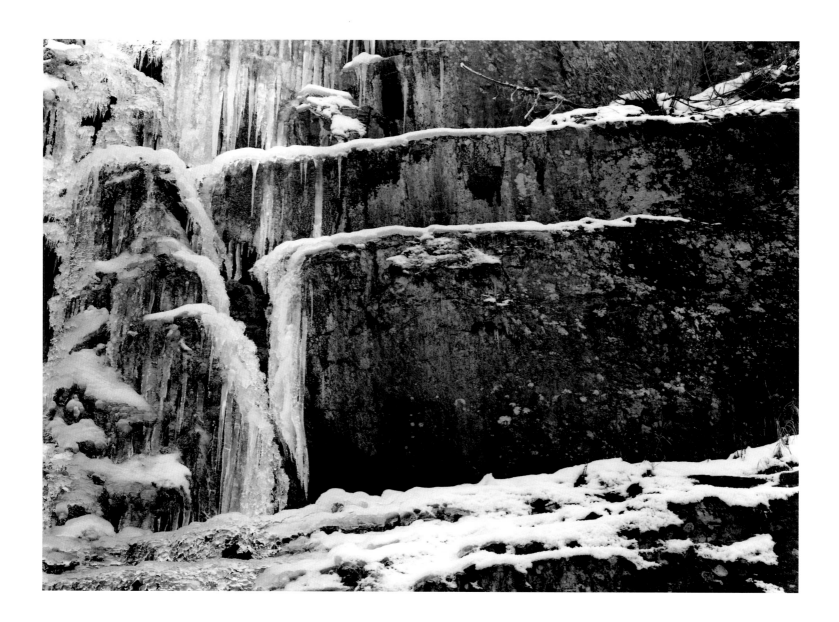

BIRCH, RED ROCK POINT, 1993

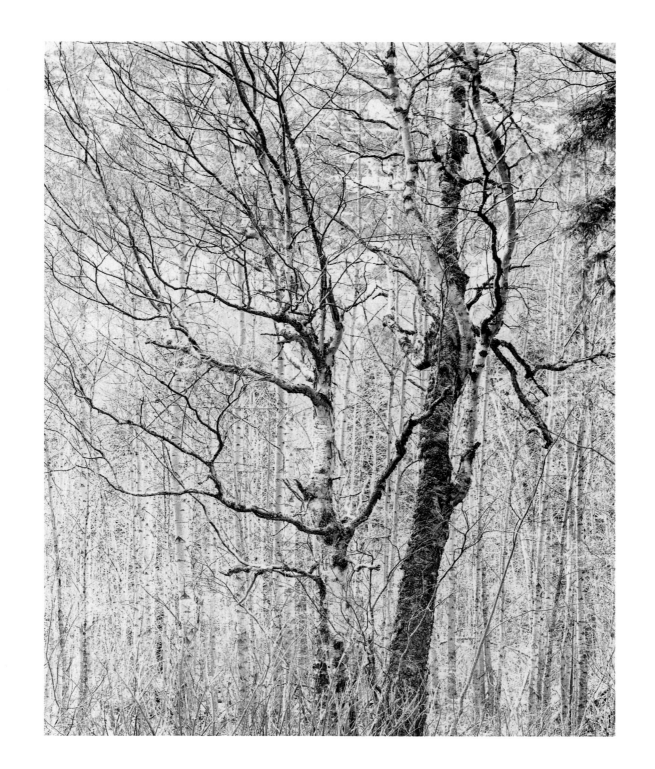

MOTH IN ICE, MIDDLE FORK, 1984

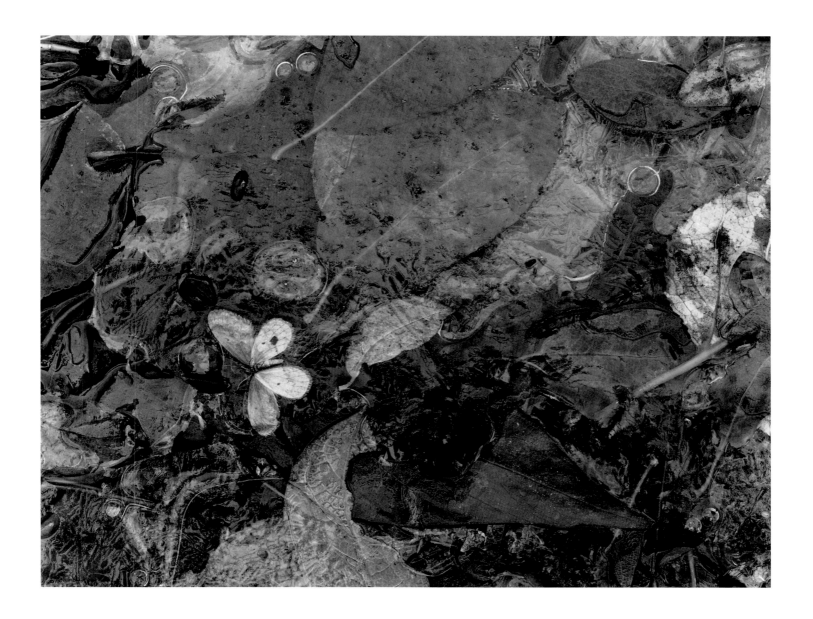

THREE BIRCHES, PACKER'S ROOST, 1979

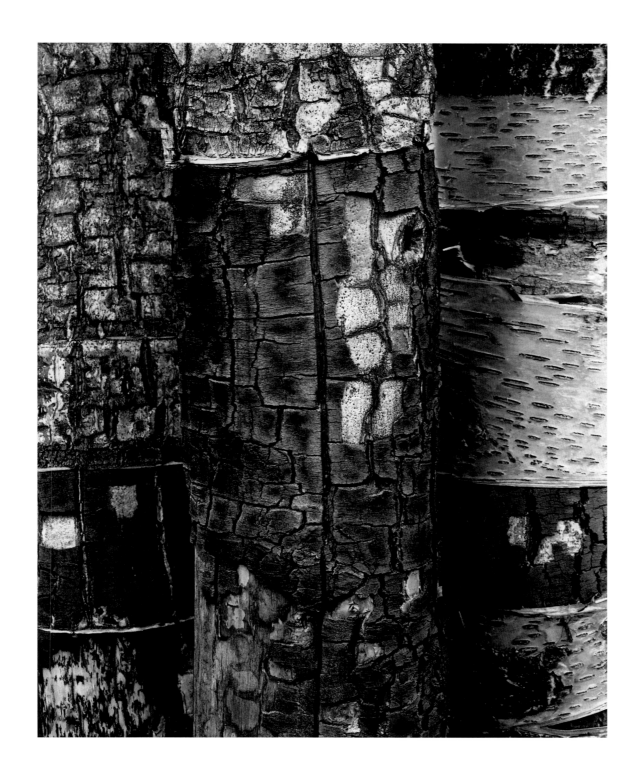

QUIET WATER, RED ROCK POINT, 1981

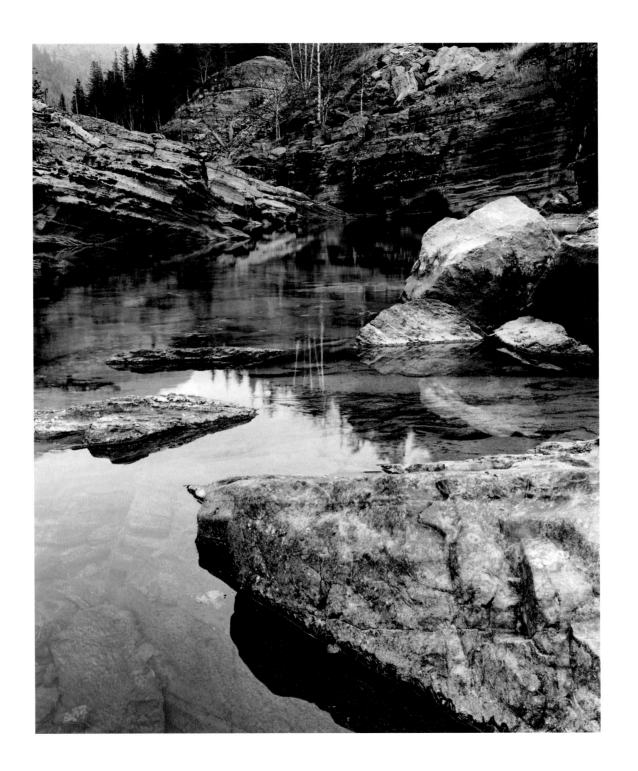

MIRROR IMAGE, SUNRISE, 1994

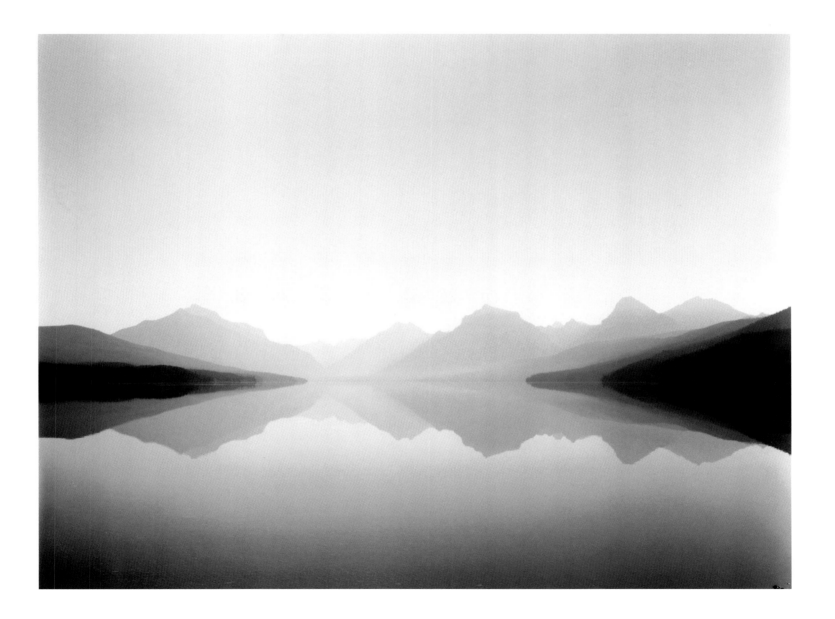

PYRAMID, FROST, 1984

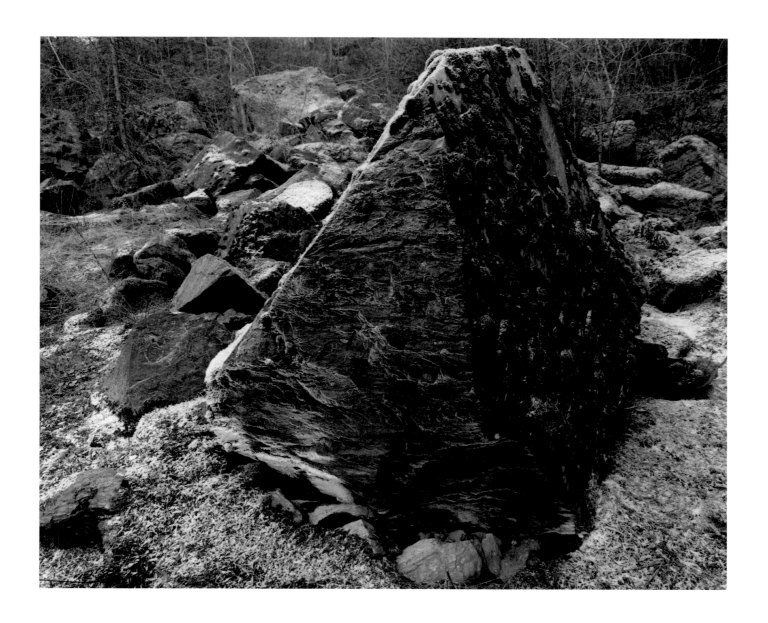

CREEKSIDE, FALL, 1993

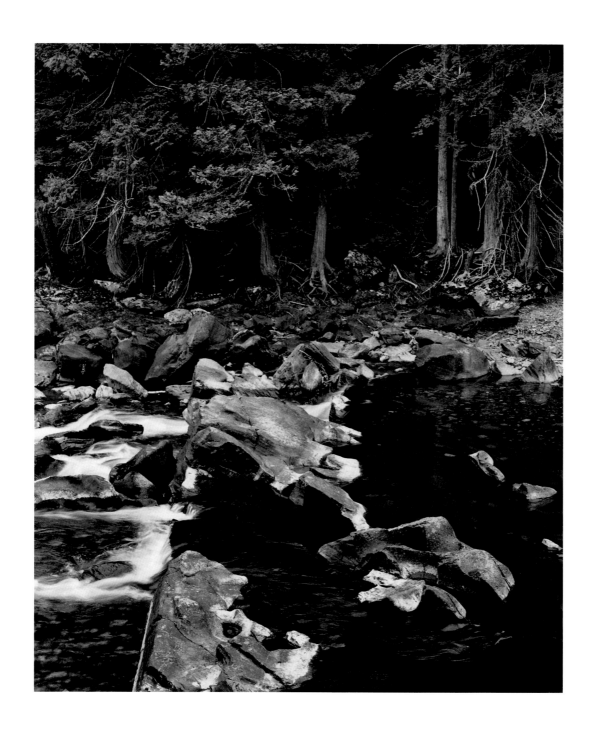

TWO DOG FLATS, SPRING, 1994

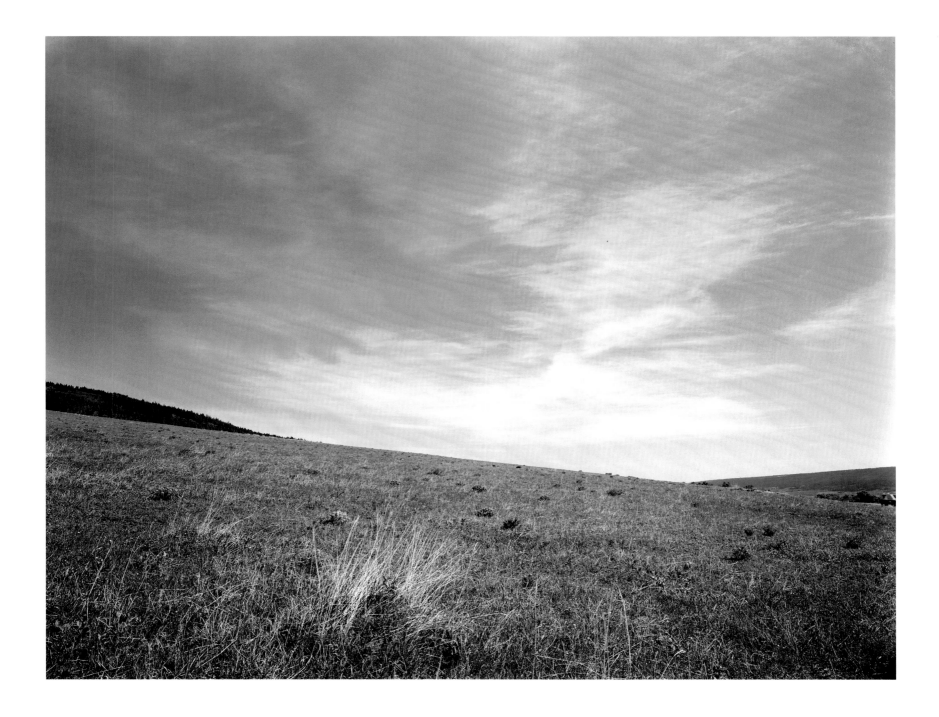

ICE AND FROST, LAKE MacDONALD, 1993

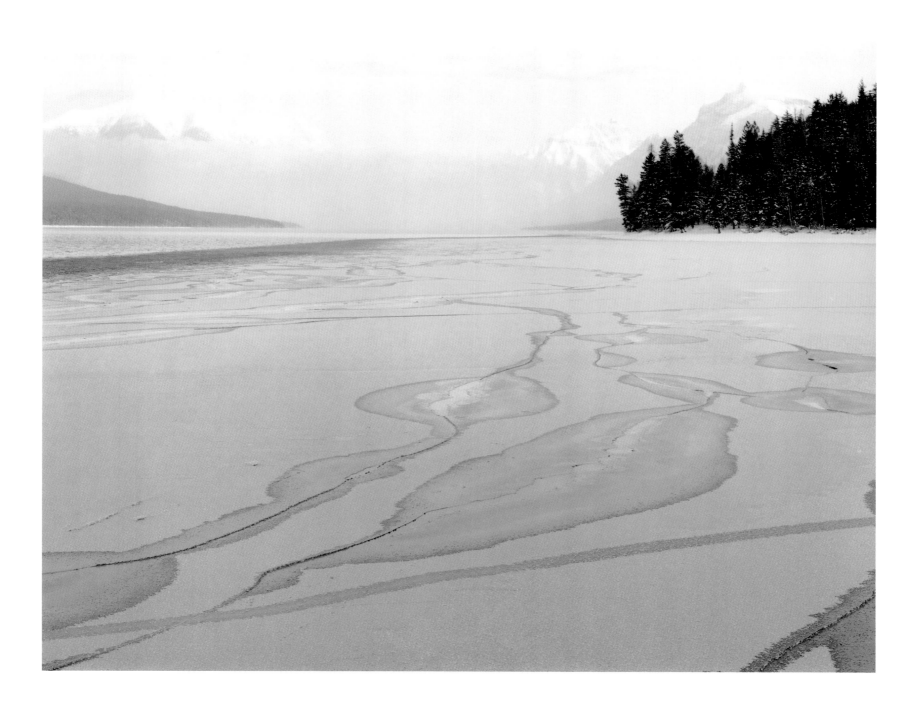

TWO ROCKS, MORNING, ST. MARY LAKE, 1994

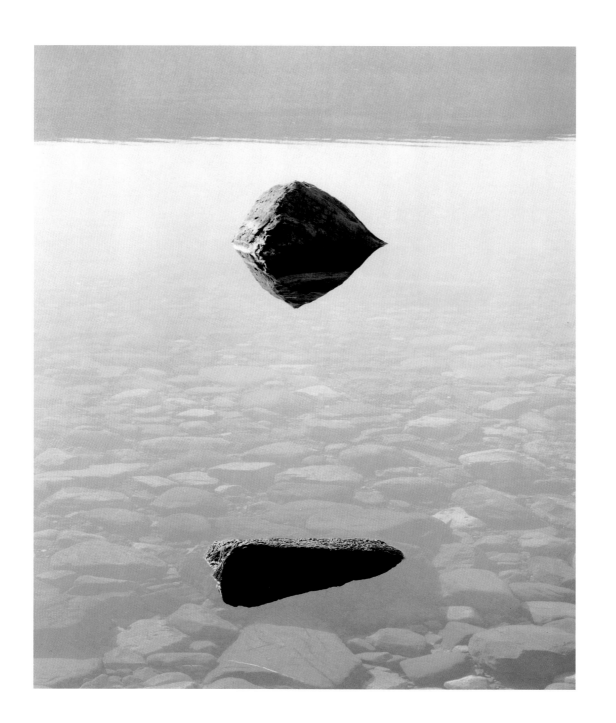

STORM, ST. MARY LAKE, 1981

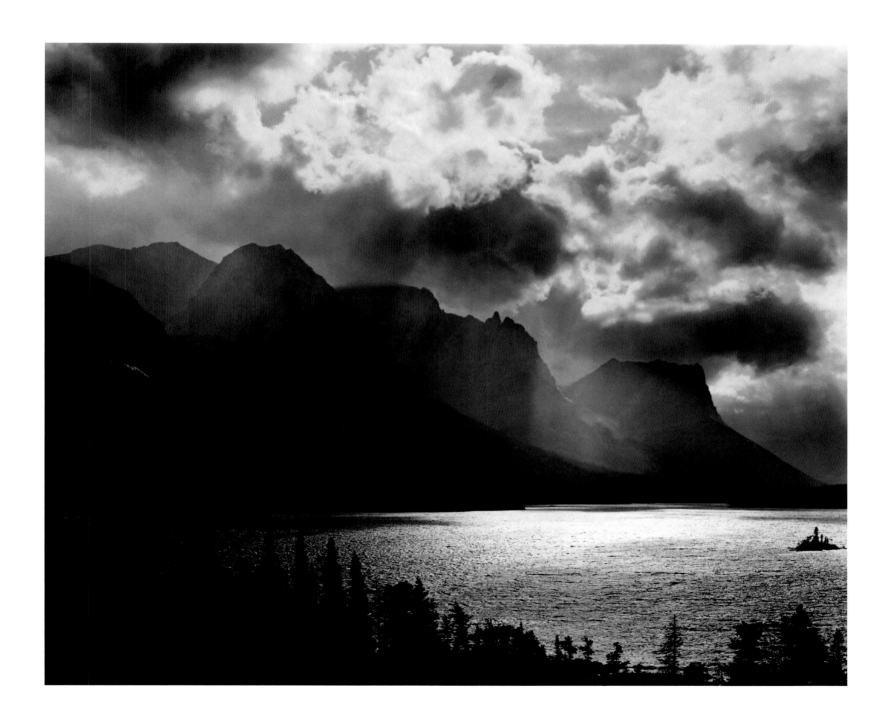

Designed by Carl Lindeman

Display set in Trajan
Text set in Adobe Garamond

Tritone negatives by Sundog Printing Limited

Printed on Quintessence by Sundog Printing Limited
Calgary, Alberta, Canada
Printing supervisor Moe Zimmerman

Perfect Bound by Alberta Trade Bindery, Calgary, Alberta, Canada

Case Binding by Atlas Book Bindery, Edmonton, Alberta, Canada

Production manager Thom Harrop